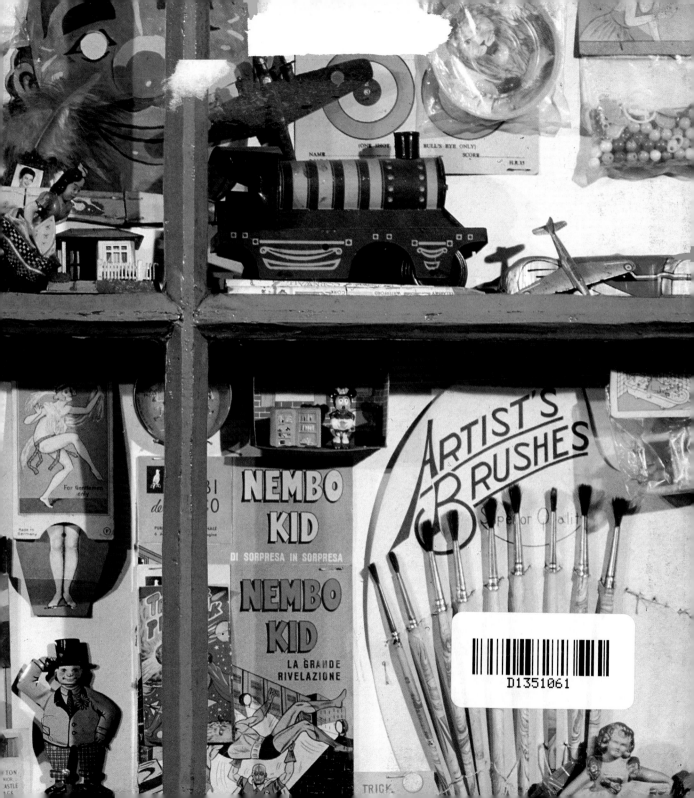

PETER BLAKE

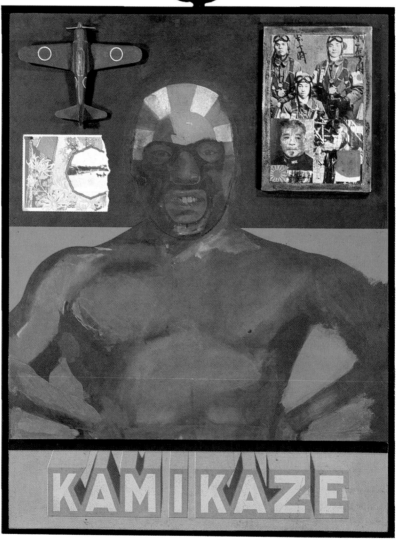

The Royal Academy · Painters and Sculptors
General editor: Mervyn Levy

PETER BLAKE

Marina Vaizey

Weidenfeld and Nicolson
London

For Peter and Chrissy with appreciation and affection
For Tom, Polly and Edward with love
For Martha with thanks

ENDPAPERS
Detail of *Toy Shop* (**17**; reproduced in full on p. 25).

FRONTISPIECE
1 *Kamikaze* (1965)
Cryla, collage on hardboard
31 x 18¾in (78.7 x 47.6cm)
Private collection

One of Blake's series of real and imaginary wrestlers
(see pp. 32–3). The subject is an imaginary
Japanese-American wrestler whose title is taken from
the name for Japanese suicide pilots during the Second
World War. A collaged portrait of pilots is incorporated
into the picture, as is a toy showing the type of plane
that would have been used by such pilots on their
suicide missions. The wrestler himself is masked, while
above his portrait there is a real Japanese mask,
wearing in turn a mask made out of fabric by Jann
Haworth which echoes that in the portrait.

PAGE 8
3 Photograph of Peter Blake by Alex Dufort, 1983. In
the background are two works in progress, *The
Wedding Hat* (**47**) and *'The Meeting'* or *'Have a nice
day, Mr Hockney'* (**31**).

Text copyright © 1986 Marina Vaizey

First published in Great Britain in 1986 by
George Weidenfeld and Nicolson Ltd
91 Clapham High Street
London SW4 7TA

ISBN 0 297 78735 7

Designed by Joyce Chester
Typeset by Deltatype, Ellesmere Port
Colour separations by Newsele Litho Ltd
Printed in Italy

Contents

List of Plates

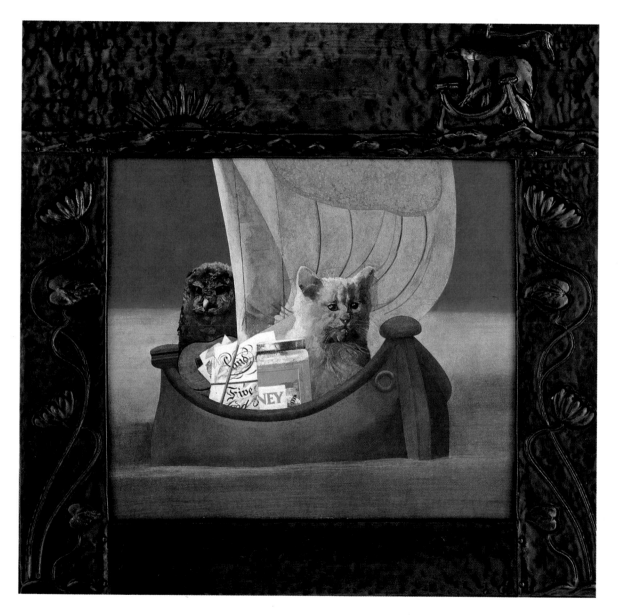

2 *The Owl and the Pussycat* (1981–3)
Oil on hardboard
10¾ x 12½ in (27.3 x 31.8 cm)
The City of Bristol Museum and Art Gallery

Blake made a reproduction of this painting, which illustrates Lear's famous rhyme, and included it as a souvenir for the public in the catalogue to his Tate retrospective of 1983. He signed some 12,500 copies.

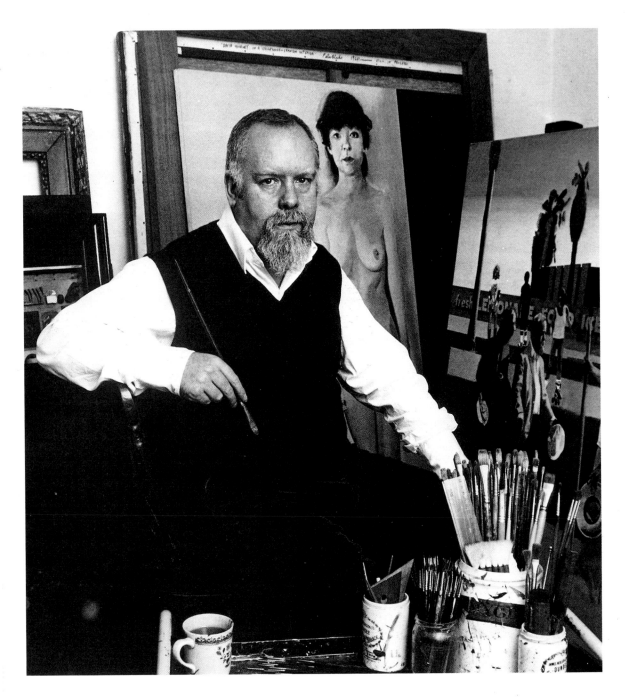

Biography

1932 Born 25 June, in Dartford, Kent

1946–9 Gravesend Technical College and School of Art Junior Art Department

1949–51 Gravesend School of Art

1950 Accepted by the Royal College of Art

1951–3 National Service in RAF

1953–6 Royal College of Art – First Class Diploma 1956

1956–7 Travelled in Holland, Belgium, France, Italy and Spain on a Leverhulme Research Award to study popular art

1960–2 Taught at St Martin's School of Art

1960–3 Taught at Harrow School of Art

1961–4 Taught at Walthamstow School of Art

1961 Featured in Ken Russell's BBC 'Monitor' film 'Pop goes the easel'. Won Junior prize at the John Moores Liverpool Exhibition

1962 One-man exhibition, Portal Gallery, London

1963 Married Jann Haworth. Visited Los Angeles to do a portfolio of drawings for *The Sunday Times*

1964–76 Taught at Royal College of Art

1965 One-man exhibition, Robert Fraser Gallery, London

1968 Daughter, Juliette Liberty Blake, born

1969 One-man exhibition, Robert Fraser Gallery, London; retrospective exhibition, City Art Gallery, Bristol; moved to Wellow, Avon (until 1979)

1973–4 Retrospective exhibition in Amsterdam, Hamburg, Brussels and Arnhem

1974 Daughter, Daisy Blake, born; elected ARA (Associate member of the Royal Academy)

1975 Founder-member of the Brotherhood of Ruralists, with Jann Haworth, Ann and Graham Arnold, David Inshaw, and Annie and Graham Ovenden; first exhibited as a group in the Royal Academy Summer Exhibition, 1976; major group exhibition at Arnolfini Gallery, Bristol, 1981, travelling to Birmingham, Glasgow and London (Camden Arts Centre)

1977 One-man exhibition, 'Souvenirs and Samples', Waddington and Tooth Galleries I, London

1979 Separated from Jann Haworth. Returned to London

1981 Elected RA (full member of the Royal Academy)

1983 Retrospective exhibition, Tate Gallery, London, travelling to Kestner-Gesellschaft, Hanover. Awarded CBE

1984 One-man exhibition, Galerie Claude Bernard, Paris

1985 Designed poster for Live Aid, world's largest ever multinational pop concert on 13 July 1985, in aid of African famine relief.

Peter Blake

In 1967 Peter Blake designed the record cover for *Sgt. Peppers Lonely Hearts Club Band*, an original purpose-built Beatles record, in typically Blakeian idiom: full of associative references and rich in visual syntax.

We see the quartet in two guises: the patently subversive Beatles in their demure grey suits and ties, a brilliant double-take on the conformity that had fragmented into a multitude of conformable non-conformities in the 'Swinging Sixties'; and also as toy soldiers, in fluorescently-coloured Ruritanian uniforms, together with a host of other human creatures, from history and from life, in costume and out, behind the kind of lavish floral tribute so characteristic of municipal celebrations. While the image, painstaking and complex, was a gift to the burgeoning academic industry devoted to studying the sociology of culture, the main point about the most famous record cover for the most famous pop group is the complicated yet curiously satisfying and deeply affectionate network of relationships that it conveys: past and present caught in a blue-skied limbo, punctuated across the foreground by the name of the Beatles spelt out in flowers. It is a small universe, everything scaled to the human figures, which them-selves are of varying sizes and are culled from reproductive media like magazines, or from photographs, reformed into new groupings for further reproductive processes.

The marriage of disparate elements to make a convincing whole is a way of visual thinking that has been a consistent characteristic of Blake's art. In some of his work there has been a seemingly simple, single subject – notably of course in portraits, such as the charmingly direct *Liberty Blake in a Kimono* (**10**). But much of his work mingles fantasy with reality: he gives to the truly fanciful a convincing edge of reality. The concept of the 'Lonely Hearts Club Band' cover is an example of that: it involved making life-size photographic cut-out figures, against which the Beatles were photographed. The crowd was thus a shadow of reality, in which the photographs mingled with a present reality – the Beatles – and were photographed again to make a collage assemblage that could exist in the artist's imagination and in the studio. The exuberant and enthusiastic, yet careful and deliberate way of choosing imagery from a wide variety of sources – from fan magazines to Lewis Carroll – has been evident,

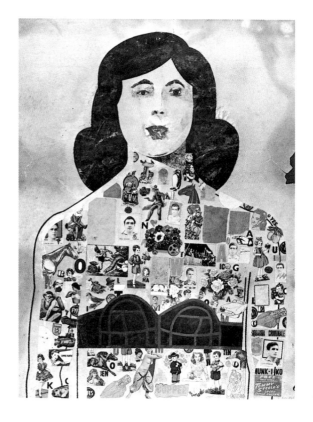

5 *Tattooed Lady with Collage* (1958)
Gouache and collage
27 x 21 in (68.6 x 53.3 cm)
Victoria and Albert Museum, London

Tattooed Lady is an elaborate collage of single letters, phrases, photographs and illustrations from a wide variety of sources – labels, packaging, publications – framed by the outline of the upper part of a stylized female body. The breasts are hidden by a painted black bikini top, but this cover-up is itself schematized with a child-like map. Several young bodies are blithely disappearing underneath the bikini. The lady's torso and arms are covered with scraps of paper, the whole reminiscent of a bulletin board or of one of those collaged screens which were a feature of the Victorian sitting room.

Other details contribute to the lady's curiously old-fashioned air: the unsmiling, calmly static pose, and her ungainly anatomy. She looks like a surreal diagram, or as though the labels plastered on to her body were part of some drawing-room game. The pose itself has affinities with early painting and primitive and folk art.

We can see here that as early as 1958 many of the interests that have affected the course of Blake's art were already strikingly apparent: the wealth of imagery from many sources that, while fascinating in its detail, is bonded together to make a satisfying whole. There is the mix of elements from 'high' and 'low' culture, a sense of the enjoyment the artist felt while collecting the bits and pieces that make up the collage, as well as that element of games playing that is such a persistent feature of Blake's work: he has 'tattooed' the lady with a patchwork of images culled from a variety of readymade sources but there is not an image that recalls a real tattoo to be seen.

The fact that the 'tattooed' area is set an inch to the right of the black line is a comment on how badly things are printed.

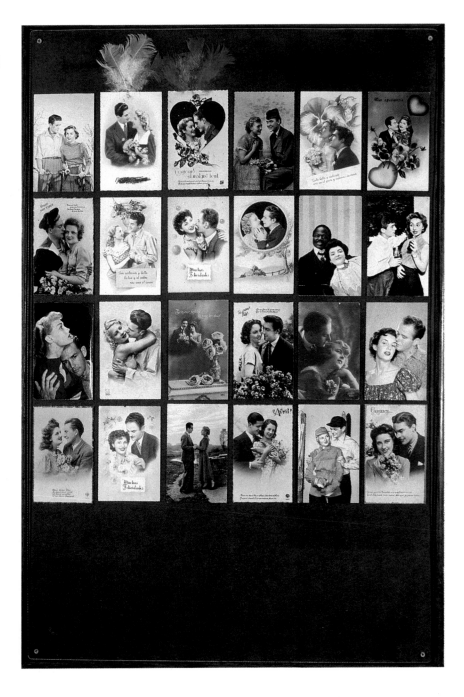

LEFT **6** *Couples* (1959)
Collage on a notice board
35 x 23½in (89 x 59.7cm)
Peter Blake

A series of postcards on the theme of 'Couples', old-fashioned and sentimental. In a mass not only do we see them more easily as a genre and view their similarities, but the power of the sentiment – a wish fulfilment, a moment of idealized repose – becomes curiously affecting. This work indicates too how, with minimal arrangement of found material, Blake can make a telling point; and how early he became preoccupied with popular portrayals of universal emotion.

RIGHT **7** *A Little Museum for Tom Phillips* (1977)
Collage
15¼ x 9½in (38.7 x 24.2cm)
Tom Phillips

Tom Phillips is a multi-media artist (paintings, prints, music, books, collages, films, photographs), much of whose work is concerned with varying degrees of perception, transformation and metamorphosis; he is particularly interested in fragments, collage and the kind of coded information contained in postcards, and has himself made imaginary museums.

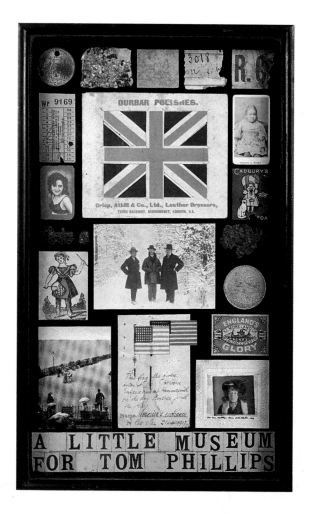

making of scrapbooks and screens, had long been a drawing-room hobby. But the mingling of real elements and paint on the same surface opened up a whole range of possibilities.

Collage could be simply works on paper where different elements, which would not have mingled in reality, were brought together to make new imagery. The Surrealist Max Ernst cut up engraved prints to make fanciful and grotesque scenes: *The Hundred Headless Woman*, made in 1927 and published in 1929, was a collage novel, told entirely in elaborate collaged images and simple but mysterious captions. As Ernst's wife, the Surrealist painter Dorothea

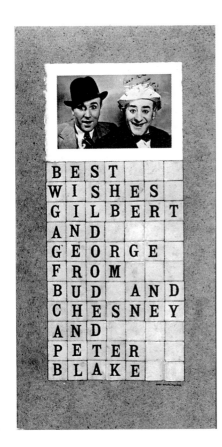

8 *Souvenir for Gilbert and George* (1974)
Collage
$17\frac{3}{4} \times 9\frac{3}{4}$in (45.1 x 24.7cm)
Gilbert and George

Blake's 'Souvenirs' are almost invariably made for and given to fellow artists, friends and family. Although Blake was not able to deliver his *Souvenir for John (Lennon)* (**9**), he had worked with the Beatles early in his career. Gilbert and George are performance artists whose early pieces – including miming with gold faces to a recording of 'Underneath the Arches', a song made famous by Bud Flanagan and Chesney Allen – brought them to the attention of a wide public.

Tanning, said of *The Hundred Headless Woman*, this kind of collage becomes 'proposals for adventure'. For the collage to work the reader, or viewer, has to bring his own wealth of associations to bear; he has to believe and disbelieve and at the same time mingle the natural and the supernatural, the ordinary and extraordinary.

That is why the hosts of characters deployed by Blake for such images as the Beatles record cover and why his tender attention to Alice – a very ordinary girl caught in an extraordinary world (the crucial reason why she is so captivating) – so fascinate us. It is a 'scissors and paste' of the imagination: elements that could only exist in the imagination are brought together, transmuted through the alchemy of art into tangible imagery.

Central to Blake's work is this sense of the artist as a kind of editor of the real and the imaginary, of past and present. Many of his paintings include the depiction of souvenirs, tangible scrapbooks of the memory.

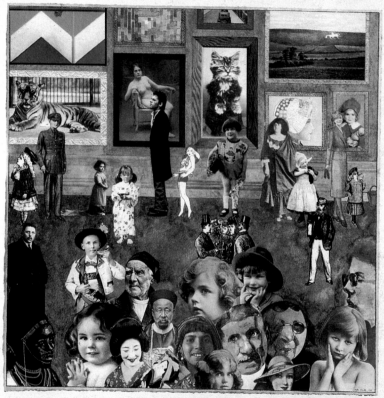

**Royal Academy 207th Summer
Exhibition of Contemporary
Paintings, Engravings, Sculpture
and Architecture**

**3 May to 27 July 1975
Admission 60p. Mondays 30p.
Weekdays 10 to 6 Sundays 2 to 6**

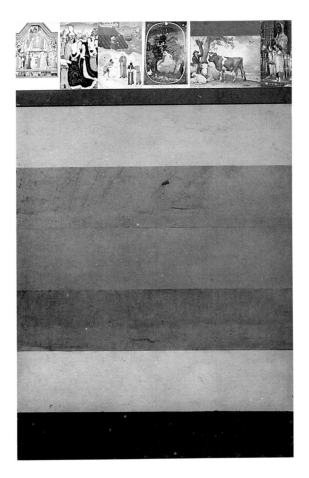

12 *Fine Art Bit* (1959)
Enamel and collage on hardboard
36 x 24 x 1 in (91.4 x 61 x 2.5cm)
Tate Gallery, London

The stripes on this painting, while visually arresting, are echoes of then current American art practice to which Europe was gradually becoming attuned, and to the decorative and memorable configuration typical of banners and flags. Thus both art as decoration and decoration as emblem are strongly evoked. Blake the artist makes his appearance as Blake the collector (if an artist is a collector, art itself, drawing upon so many sources to make new intelligibilities, is something of a magpie) with the row of fine art postcards, brought back from his European travels, collaged at the top. The title is gently ironic: the image can be read, ambiguously, as both tribute and affectionate send-up. The brushwork is unusually varied so the stripes are almost succulent, while the richness of association usual in Blake's work is miniaturized in the postcards.

Hayward Annual of 1977 was an instance of this.

Characteristically, the first work to greet visitors to Blake's 1983 Tate Gallery retrospective was his *Sculpture Park* (**57**), a vast table-top exercise in miniaturization. The models were made by the artist Chrissy Wilson with whom Blake lives in Chiswick in a typically English setting: an Edwardian end-of-terrace villa in a dense suburban street at right angles to the busy Chiswick High Road. The miniatures were art-world Disneyland, exercising the powerful fascination of dolls' houses, model railways, toys; but here we might discern on the lawns, indeed a kind of Forest Lawn of modernism and other 'isms', toy-town replicas of Henry Moore, Brancusi and other giants of modern sculpture. Blake says that one of his favourite sculptors is Brancusi. This is

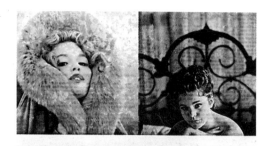

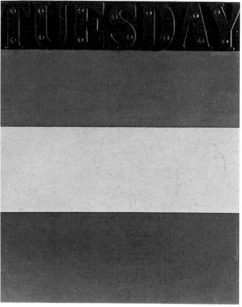

13 *Tuesday* (1961)
Enamel paint, wood relief and collage on hardboard
18¾ x 10⅛ x 1½in (47.6 x 25.7 x 3.9cm)
Tate Gallery, London

The very young but very knowing female movie star has been a notable postwar phenomenon. (Shirley Temple was a prewar child star but she was not very knowing; the early allure of Elizabeth Taylor was based on innocence.) Carroll Baker exemplified the type in *Baby Doll* (1956), while in the 70s Jodie Foster and Brooke Shields portrayed younger but even more sophisticated adolescent non-innocents. This is part of the cultural matrix of this picture, devised partly because Blake liked the ambiguity of Tuesday Weld's forename. Two photographs of the teenage actress appear above a sequence of ready-made plastic letters which spell out her name. More than half of the construction is taken up with broad bands of primary colours – red, yellow and blue – painted in housepaint: with its radically simplified colour field, a reference to 'Hard-edge' painting then fashionable in New York, and to explorations elsewhere into the use of modulated hues of single colours. As is so often the case with Blake's imagery, he has managed to blend popular and high culture in one object.

surprising as streamlining is the very last thing that strikes one about Blake's imagery: rather it is baroque with a passionately disciplined appetite for ornament and decoration. (One definition for art among the many hundreds possible is to consider it as an ornamented and ordered version of reality.) Blake's other favourite is H. C. Westerman, an original roughie-toughie of American sculpture with affinities for the

unexpected. Perhaps the two sculptors represent polarities evident in Blake's own work: extraction, refinement, distillation, a longing that is almost atavistic for essentials; and the art of incorporation, of assemblage and collage, nurtured by an unselfconscious but intense feeling for the genuinely popular.

The Tate retrospective of 1983 still holds the record at the gallery for the most visited

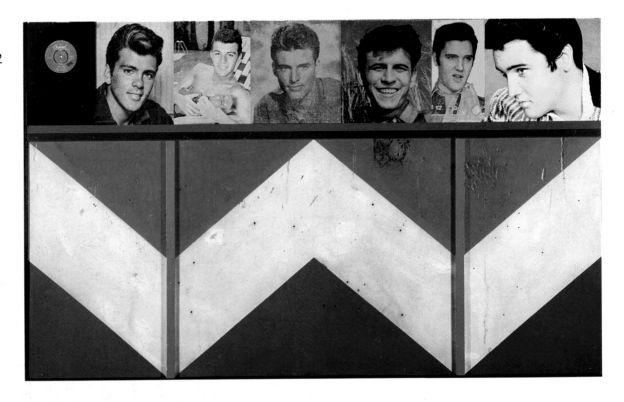

exhibition, on a daily basis, of any living British artist – indeed of any living artist save Salvador Dali. Blake produced for visitors a free souvenir and signed 12,500 of them: a reproduction of his own elaborately framed painting of a scene from Edward Lear's nonsense rhymes, in this case *The Owl and the Pussycat* (**2**), setting out for sea in a beautiful pea-green boat. Lear, like Lewis Carroll and Peter Blake, was a polymath; best remembered for his nonsense rhymes, he was also a traveller – in the nineteenth century the English went to the Middle East and India as they now go to California – and

landscape artist. Carroll, famous for creating an imaginary world whose characters have entered the language as metaphors for a whole spectrum of activities, attitudes and behaviour, was also a gifted photographer and a professional mathematician.

Blake, although firmly in the English tradition which embraces a sturdy reliance on the most exquisite workmanship and an appreciation of the craft of art, is working at a time when sophisticated and extensively educated people are frequently absorbed by the images, significance and meaning of mass culture. Blake was a student at the

LEFT **14** *Got a Girl* (1960–1)
Enamel, photo collage and record
37 x 61 x 1⅝in (94 x 154.9 x 4.2cm)
Whitworth Art Gallery, University of Manchester

This collage and construction includes the actual
record of 'Got a Girl' by the Four Preps, the plot of
which describes a young girl who can only think
of pop stars when her boyfriend kisses her. The
pin-up pop stars include Elvis Presley twice.

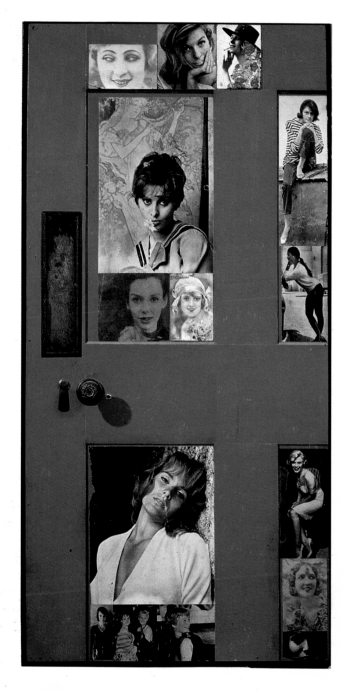

RIGHT **15** *Girlie Door* (1959)
Collage and objects on hardboard
48 x 23¾in (121.9 x 59.1cm)
Private collection

The door is not real but painted to imitate one,
while the pin-ups are real, from Blake's own
collection, and include Marilyn Monroe.

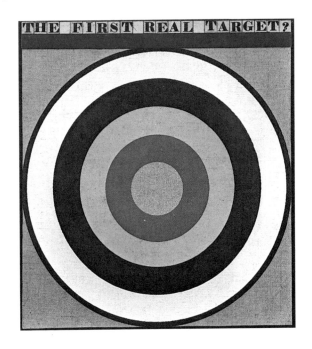

THE FIRST REAL TARGET?

16 *The First Real Target?* (1961)
Collage on hardboard
20 x 18in (50.8 x 45.7cm)
Tate Gallery, London

This collage echoes American painting of the time, referring especially to Jasper Johns' 'target' paintings. Where Johns actually painted his targets – and richly at that with a repertoire of modulated brush strokes – Blake purchased his: a Slazenger archery target. Having made something real into a decorative motif, Blake queries whether this activity makes the first real target – in fine art terms.

Royal College of Art in 1950s, a few years before R. B. Kitaj and David Hockney. They shared an understanding of the importance of drawing, and especially of drawing from life. They also shared an awareness of the images of culture – of packaging, wrapping and the like. One of Kitaj's famous series was prints of fifty well-known books: books, in dustjackets, are wrapped objects. An early Hockney painting was of a package of Typhoo tea.

In 1956 Blake was awarded a Leverhulme Research grant to enable him to study popular art on the Continent. In popular art the image of the person – hero or heroine, real or fictional – carries a potency beyond that of the simple portrait. Aura and image mingle, reflected in the vocabulary that calls an entertainer a 'star'. Of Elvis Presley, who figures in a large variety of Blakeian imagery, Blake said that he himself did not particularly respond to Presley's music: 'I'm a fan of the legend rather than the person.'

Blake operates in a curious territory he has made very much his own. For he is interested in the popular arts that are not mediated through the media – wrestlers, the circus, music hall and carnivals, pin-ups, strippers – but which depend on a live audience. (Some manifestations may be televised, but these forms of entertainment are not usually designed primarily for television.) He is also interested in the more distanced pop music scene. Performances of

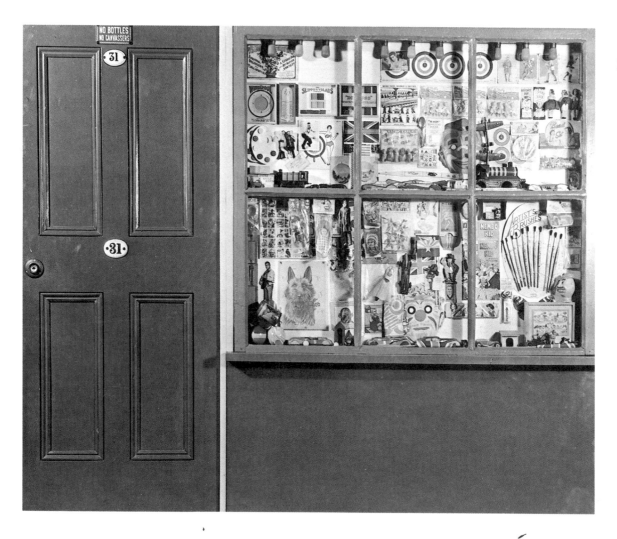

17 *Toy Shop* (1962)
Collage construction
60½ x 75½ in (153.7 x 191.7cm)
Tate Gallery, London

The construction is actually a method of storage and display for some of the toys that Blake collected as well as a work of art. The cupboard door, used illusionistically as a shop door, adds to the feeling of miniaturization which is created; both door and window were found on a building site in Chiswick, West London. The miscellany of objects includes several kinds of targets as well as items such as toy airplanes and paper hearts, and there is a good deal of toy and real (i.e. functional) artists' equipment: brushes and palettes. The toys are displayed in ordered profusion — heaped in abundance yet forming arrangements, still lifes, both clear and pleasing. A string of fairy lights is lit up when the painting is on display, adding to the sense of festive celebration.

18 *On the Balcony* (1955–7)
Oil on canvas
47¾ x 35¾in (121.3 x 90.8cm)
Tate Gallery, London

One of Blake's best and most well-known paintings, it is complex while at the same time curiously straightforward. Characteristically he has packed the picture with allusions – not only to other famous images (such as Manet's *On the Balcony*, itself a curiously ambiguous painting engendering debate as to the significance of the subject) but to contemporary art in the style of fellow students of the Royal College of Art (Denny, Kossoff, Richard Smith). He includes, in the domestic tableau on the table in the foreground, allusions to 'kitchen sink' painting or social realism which was much debated and even practised in England at the time when one of the most controversial and stimulating critics was John Berger. A painted copy of the *New Statesman*, where Berger sometimes wrote, nestles on the table.

The painting is in some way about growing up: the children by their uniforms, imposed by adults, are part of a school group; but the badges they wear and the pictures they hold identify them with popular culture and personal interests beyond school. Their ageless faces are blandly without expression. It is unclear whether they are in a room or outdoors: they sit either on a park- or school- bench, although the connotations of the schoolroom are strong – perhaps a dig at the fact that the painting is centred on a subject set by the Royal College.

pop tend to take place in huge arenas and a collective hysteria frequently grips the audience. The phenomenon is that of making a pilgrimage to see the stars live on stage.

On the Balcony (**18**), the subject set by the Royal College of Art for its diploma composition, is one of Blake's earliest and most major paintings. It exhibits the kind of simplified elaboration, or elaborate simplification, that is the hallmark of his work. It resonates with references and yet is graspable by any spectator; it is a beautiful, affecting and poignant painting, but above all full of interest.

The process of its making typifies Blake's working methods. It is immaculately crafted: *trompe-l'oeil* collage not real collage. It took as its inspiration another work of art, one that contained simulacra of many other paintings – the American realist Honoré Sharrer's *Workers and Pictures* of 1943. This painting came to London in 1955 for an exhibition of American art at the Tate, but was never hung and Blake saw it in storage at the American Embassy. Sharrer's picture shows working-class Americans grouped in front of tenements and factories, with carefully portrayed reproductions of famous paintings in the background. The artist regarded it as a realistic examination of the lives of working people, or at least a metaphor for reality, executed in 'a vicious, tender and meticulous style'. Certainly Blake's style and method could be described equally well as tender and meticulous.

The painting contains within it about twenty-seven variations on the theme 'on the balcony'. It is a configuration much used in visual imagery, not to mention opera, and has surprising over- and undertones. The dictator reviewing his troops takes the salute on the balcony. But with Blake we find revealingly that 'on the balcony' images that suggest fascistic and dictatorial modes, which would have been easily accessible

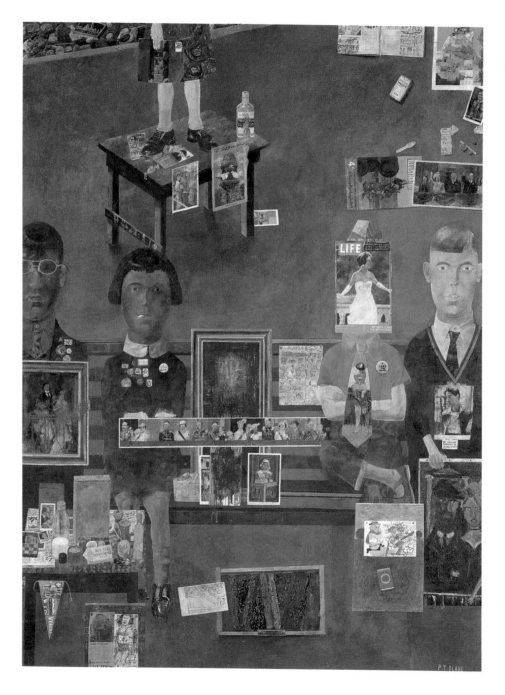

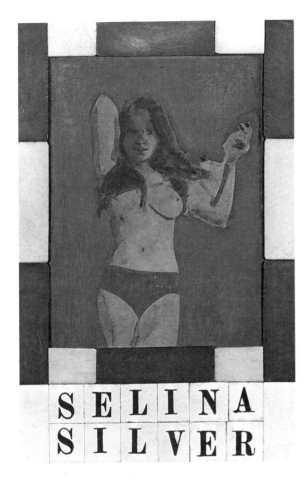

19 *Selina Silver* (1968–77)
Oil on panel
9¾ x 6¾ in (24.8 x 17.2cm)
Private collection

The pin-up is that combination, characteristic of Blake's work, of overt sexuality – big, ripe breasts displayed to advantage – and girlish, innocent face. The image is based on a photograph in a magazine. The lettering comes from a children's game, and the border is made up of coloured counters.

photographically as source material, have been eschewed. There is an uncontrived innocence about Blake's art however knowing it is. We have the Royal Family twice; Manet's famous painting *On the Balcony*; endearing pastiches of the work of Robyn Denny, Leon Kossoff and even Richard Smith – all fellow students of Blake's at the Royal College; we have pin-ups and innocent erotica; and in a fascinating interplay between the sophistication of the media and mediated imagery, we have four – or four and a half – young people who are perhaps pre-pubertal, possibly adolescent, or even young adults. The charming solemnity of the scene, the flattened perspective, the play with badges, the boy masked by the cover of *Life* magazine, the collection of cards and pennants, suggest the classroom, the bedroom or playroom whose walls are covered

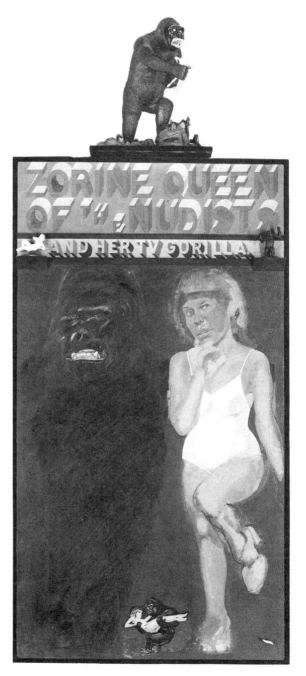

20 *Zorine, Queen of the Nudists and her TV Gorilla*
(1961–5)
Collage
$45\frac{1}{2} \times 20\frac{1}{2}$in (115.5 x 52cm)
Private collection

An elaborate collage painting and construction which
portrays in imaginary form a real act which Blake had
heard about. The changing scale of the figures of the
gorilla and stripper are a reference to the film *King
Kong*; a musical box attached to the picture plays
'Some Enchanted Evening'.

with favourite images – very much a
growing-up activity.

Blake was twenty-three when he started
the painting, only twenty-five when he
finished it. It is one of his early paintings
which seems a curious pre-echo of what was
to follow: for so much of his career Blake has
been with gusto a kind of one person culture
club; he mingles in his imagery high and low
art, the vulgar, the common, and the

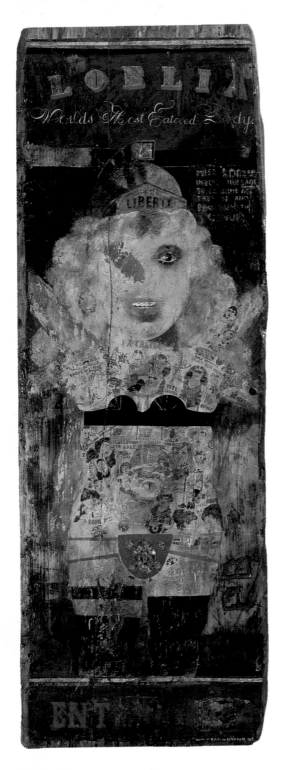

21 *Loelia, World's Most Tattooed Lady* (1955)
Oil and collage on panel
29½ x 10½in (74.9 x 26.7cm)
Fleur Cowles

Loelia has many arms, like an Indian goddess, and is much weathered. Several styles, from careful realism to folk fantasy, can be seen in the image which moves from creative confusion to creative coherence.

rarefied, reminding the spectator painlessly of the complex and surprising interchanges between these areas of transmitted imagery.

Blake first applied to the Royal College of Art for a place on the graphic design course, and it is noteworthy how consistent his interest in design and presentation has been through well over three decades as a professional artist. It is shown not only through his almost obsessive passion for ephemera, his use of various modes of mark making, the printed word, the printed page, and his fascination with reproductive processes, but in the continued and striking emphasis on accessibility in his imagery. Typically, we come face to face with a Blake portrait: we meet each other head-on. Of course this is also true of lettering and signs which we can't read from an angle.

Display is a crucial element of art. When debating the aesthetic merits of imagery, and the ideology a given image may embody, we often abandon discussion of the fundamental characteristics of good art and say that it must somehow be visually interesting or catch the visual imagination, that it must be memorable.

Imaginative and fantastic ways of displaying the self are often explored in paintings

22 *Siriol, She-Devil of Naked Madness* (1957)
Oil and collage on panel
29½ x 8½ in (75 x 21.6cm)
Private collection

Here is the huge face, the ambiguity as to age, and the flirtation with fantasy and reality that are so characteristic of Blake's work. She looks like some battered relic of a travelling circus.

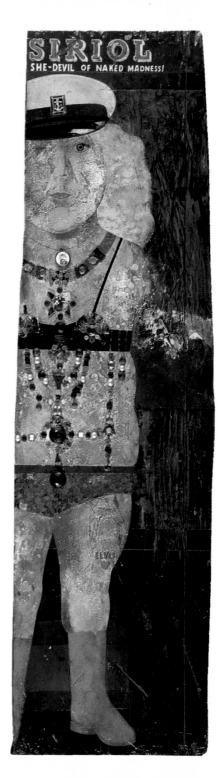

by Blake. Early on, in the mid to late 1950s, he painted a series of oils, and oils with collage, on the theme of imaginary entertainers: *Dixie, Darling of the Midway*; *Siriol, She-Devil of Naked Madness* (**22**); *Cherie, Only Bearded Tattooed Lady*; *Loelia, World's Most Tattooed Lady* (**21**). Strippers were a theme in the early 1960s, also imaginary though real source material played an important part in their conception: *Nudina, Kandy, Zorine, Queen of the Nudists and her TV Gorilla* (**20**).

We know that appearances can deceive. Deception – professional deception – is crucial in the world of entertainment. Certain contrasts too can be painfully piquant. This is so in another image of a fictional stripper, *Selina Silver* (**19**), where the girl's face is as candid as Blake's vision of Alice, but her body, while slim, is mature and voluptuous.

Both imaginary and real are contained in Blake's series of wrestlers, also of the 1960s though some were completed much later. Among the imaginary figures are *Little Lady Luck*, a lady wrestler who is possibly Irish; *Doktor K. Tortur* (**33**), a German; *Les Orchidées Noires*, a pair of French lady wrestlers; and *Kamikaze* (**1**), an American. Yet *Kid McCoy* and *Masked Zebra Kid* (**23**), elaborate painting

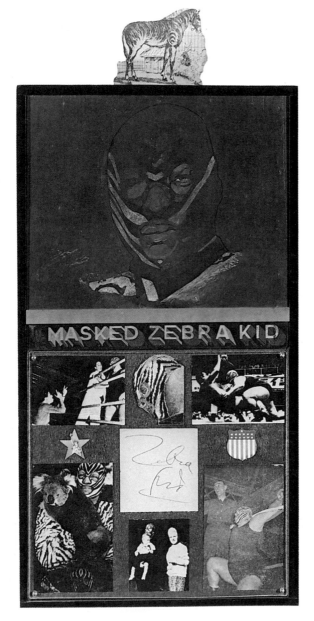

23 *Masked Zebra Kid* (1965)
Cryla and collage on panel
21¾ x 10½ x 1½ in (55.2 x 26.7 x 4 cm)
Tate Gallery, London

Typical of Blake's mixed media assemblages of the mid-1960s, it takes as its basis and its name a real-life American wrestler, the Masked Zebra Kid, and even includes his autograph as a prominent centrepiece, obtained by Blake after seeing him perform at the Hammersmith Commodore. Photographs taken from *Boxing and Wrestling Illustrated* are found in the collage, while overseeing the action there is a large and dominant portrait of the masked wrestler's head, based on a photograph from the same source but deliberately darkened. The illusionistic lettering which identifies the subject is of a traditional type often used by signwriters: Blake's earliest art training, at the Gravesend School of Art, had been in the field of graphic design.

and collage constructions, are respectively a real American boxer and a real American wrestler. While Blake's satisfying and complex images may refer upon occasion to attributes beyond the public appearance (the lettering of *Les Orchidées Noires* between the painted images of two trimly calm young women is surmounted by period photographs of the wrestlers as children), the burden of the imagery is concerned with entertainers – whether from circus, music hall, club, boxing or wrestling ring – in their public personae, whether real or not.

This preoccupation has strong affinities with other themes in his work, especially in his paintings of the world not of very young

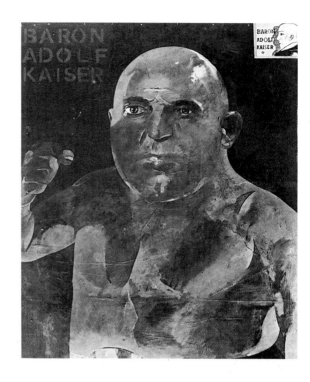

24 *Baron Adolf Kaiser* (1961–3)
Oil and enamel on hardboard
24 x 10 in (61 x 25.4cm)
Arts Council of Great Britain

The first in a number of portraits of wrestlers who feature prominently in the crowd of freak and fringe entertainers that absorbed Blake in the 1960s. The overlarge head – a feature of many of his portraits, both real and imaginary – and ritualistic gesture contribute to the mood of the portrait as a whole as one of curiously bland aggression.

children (except in the case of portraits of his own family) but of teenagers just at that period of dressing up, role playing, discovering the reality behind appearances, attempting to descry the truth in an adult world where all may appear to be hypocritical pretence.

Role playing and an interest in uniforms and costumes extends throughout Blake's work and was evidenced early in two remarkable self portraits. From the early 1950s, painted during his national service, there is a gouache, *Self Portrait* (*In RAF Jacket*) (**25**). Blake, wearing an RAF jacket and harlequin trousers, has painted himself standing looking straight out of the picture

against a background of circus ephemera. The poignant solemnity which one finds in Victorian photographs can be seen in his portrait of his sister Shirley of 1950 and in his *Self Portrait with Badges* (**26**) of 1961, with which he won first prize in the junior section of the John Moores Liverpool Exhibition in that year. In this picture Blake is wearing blue jeans, denim jacket and baseball boots before such an American outfit was common currency. The idea of wearing badges and emblems was utilized in *On the Balcony* (**18**) and in many of the collages and constructions which act in some ways as exceptionally sophisticated bulletin boards (and curiously echo the collaged screens made by

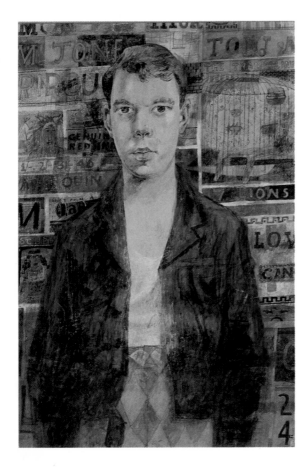

25 *Self Portrait (In RAF Jacket)* (c. 1952–3)
Pen and ink and gouache on paper
13½ x 9¼ in (34.2 x 23.5 cm)
Private collection

26 *Self Portrait with Badges* (1961)
Oil on hardboard
68 x 47½ in (172.7 x 120.6cm)
Tate Gallery, London

Blake has painted himself wearing baseball boots, jeans
and a denim jacket which is festooned with badges.
Others of his pictures show people wearing badges but
they are always children or adolescents (for example,
On the Balcony, **18**, and *ABC Minors*). He used to wear
badges at this period but just a few at a time, not a vast
collection as here which makes him look like a veteran
decorated with medals and campaign ribbons. Many
are from America, including one with 'I like Fiorello'
(Fiorello La Guardia was a controversial and colourful
mayor of New York), an American Boy Scout badge, an
Elvis Presley badge and a campaign badge for Adlai
Stevenson (the unsuccessful American Presidential
candidate who was much admired in Europe).
References are also made to pop groups, Union Jacks,
Max Wall (the English music-hall tragi-comedian) and
even to the First World War.

Portraiture, real or imaginary, is central to Blake's
work. While many of his portraits concentrate on faces
alone, others are labelled and named as an integral part
of the image (for example, the series of wrestlers, **1**, **23**,
24, **33**, **34**) and contain what in Renaissance terms
would be called attributes: signs of the sitter's
vocation, avocation, occupation and also emblems of
his or her place in society as well as indications as to the
nature of that society. This, combined with the
awkward, compelling directness of his figures,
reflected in their pose, puts his portraits firmly in the
historical mainstream of Western portraiture. While
revealing the influences of hieratic, archaic types from
Byzantium, they remain startlingly specific to Blake's
own times.

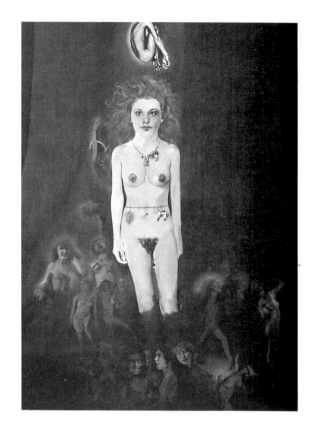

28 *Titania* (as exhibited in 1983)
Oil on canvas
48 x 36in (121.9 x 91.4cm)
Waddington Galleries

imagery, he conveys a magical sense through a combination of knowingness and innocence. *Titania* (**28**), a painting that has undergone many transformations, combines the body of a young, sexually mature girl-woman with a candid face that is not in the least ethereal. It is a curious echo of the combination of sexual maturity and other-worldly innocence to be found in *Selina Silver*. At first, the *Titania* nude was straight-forward. In the version seen at the Tate retrospective, flowers had been cunningly plaited into her luxurious pubic hair.

Although jealousy and strife are often endemic in the fairy world, sexuality frequently is absent (a peculiarly distorted echo of the world of angels and fallen angels). Thus it may be a contradiction to think in terms of full-blooded fairies. But Blake, as in the Alice watercolours (**51–6**), dresses fantasy in reality; he is a believable surrealist. His fairies are both creatures of the flesh and creatures of fantasy.

Blake's paintings, often from colouristically dull sources, bring his images visually to life. In the series of paintings of people from

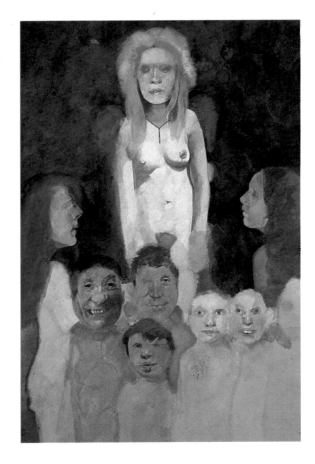

29 *Titania's Birthday* (1975)
Watercolour
22¾ x 15½in (57.8 x 39.4cm)
Museum Boymans-van Beuningen, Rotterdam

Constantinople (**45–6**), taken from picture postcards printed in Italy but published in France *c.* 1900, Blake's colours are much more vivid than those of the originals. He makes of the ephemeral something that is simultaneously classic and nostalgic. He has said that for him 'pop art is often rooted in nostalgia; the nostalgia of old, popular things'. While 'continually trying to establish a new pop art, one which stems directly from our own time', he declared that he was 'always looking back at the source of the idiom' – to some sort of folk roots.

At the same time as re-creating imagery from popular culture, Blake deliberately courts references to the fine arts, and to other painters past and present. As he collects all manner of things from the popular to the high arts, as he makes 'souvenirs and samples' and what he has called 'little museums' for his friends, so some of his paintings – for example *On the*

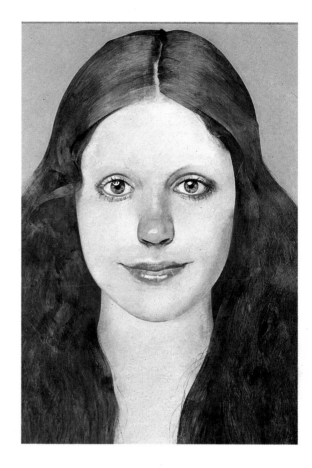

30 *Titania* (1972–4)
Oil on board
7 x 4⅝in (17.8 x 11.8cm)
Private collection

Titania has been painted in many ways by Blake. In this, the earliest portrait of her in oils, only the head is shown, framed by gay abundant hair, her eyes large, candid and blue.

Balcony (**18**), *The First Real Target?* (**16**) and *'The Meeting' or 'Have a nice day, Mr Hockney'* (**31**) – refer emblematically to other paintings. There is also the absolutely straightforward incorporation, as in his masterly and beautifully executed copy of Landseer's *The Monarch of the Glen* (**32**), which was painted not from the original but from a reproduction. It is painting which has life in the popular imagination as a cliché for excrutiatingly bad but memorable High

Victorian art. Recently, as the commercial and curatorial rehabilitation of Victoriana continues on its successful path, it has been incorporated back into the fold of critically acceptable art.

In one sense Blake is a rehabilitator too, or rather, through his own alchemy, he turns tin into gold: he is an artist whose persistent enthusiasm refuses to recognise any hierarchy of images or of sources, quarrying as he does from such a wide variety of media.

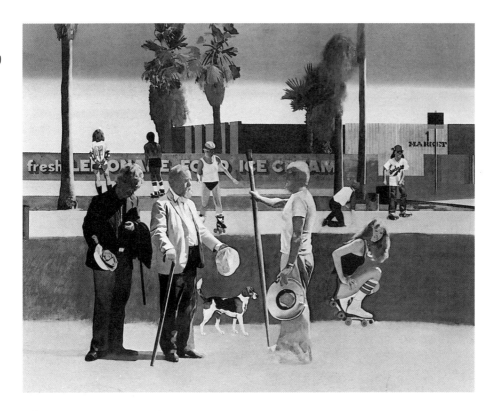

31 *'The Meeting' or 'Have a nice day, Mr Hockney'*
(1981–5)
Oil on canvas
38½ x 48¾in (97.8 x 123.8cm)
Tate Gallery, London

In 1979 Blake and Howard Hodgkin, at a time of
personal crises in both their lives, together visited David
Hockney in Los Angeles. The two later agreed to paint a
trio of pictures to commemorate the visit (another
example of Blake's continual emphasis on the souvenir,
the embodiment of memory). This painting, one of
Blake's trio, is based on Courbet's famous image of the
bravura of the artist – *The Meeting*, also known as
Bonjour Monsieur Courbet (1854) – itself derived from a
popular print, *The Wandering Jew*. Courbet's painting
shows the artist with his walking stick being greeted by
his wealthy patron and host M. Bruyas who is
accompanied by his manservant. Courbet himself

remarked that the painting was criticized for being 'too
personal and pretentious', but it became one of the
best-known paintings in France, plagiarized and
imitated, cartoonists especially having a field day.

Blake's affectionate homage to Courbet uses in its
title the ubiquitous American phrase 'Have a nice day'.
The setting is Los Angeles, or possibly Venice,
California, by the sea. In the brilliant sun the two visiting
painters, both formally dressed in jackets, play the part
as it were of Bruyas and his servant, while Hockney,
their Angeleno host, as Courbet, is informal in T-shirt
(the roles are reversed in the Courbet painting where he
is the visitor). It is a playful painting, full of controlled
exuberance and mutual respect. It echoes in
sophisticated fashion that slight sense of the promised
land, both physical and mental, which is subtly hinted at
in Courbet's masterpiece. The dog, modelled on one in
a painting by Stubbs, was added after the Tate
retrospective – Courbet's original having one.

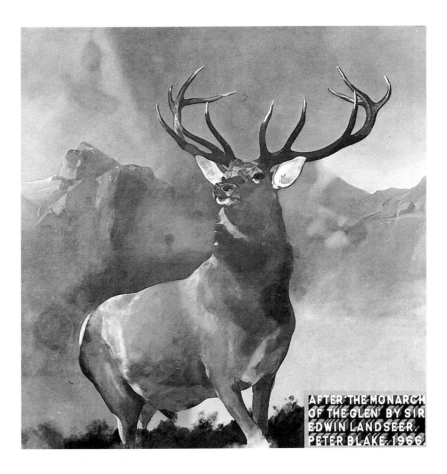

32 *The Monarch of the Glen* (1965–8)
Cryla on canvas
48 x 48in (121.9 x 121.9cm)
Paul and Linda McCartney

Commissioned by Paul McCartney, but suggested as a subject to the singer by Blake, and painted from a reproduction. The original, painted in 1851 by Sir Edwin Landseer, one of Queen Victoria's favourite artists, is one of the most famous – or notorious – images in all nineteenth-century British art. It was conceived by Landseer as part of a decorative scheme for refreshment rooms in the House of Lords; when that foundered, the painting spent over fifty years in various aristocratic private collections until bought by Thomas Dewar in 1916. Now owned by John Dewar & Sons, it is identified with Scotch whisky. Blake, himself a contributor to the famous series of portraits for Pears Soap, has often incorporated the styles and images of other artists into his own paintings, an activity related to working from media sources, using collage and painting from reproductions including postcards. This, however, is a rare example of an entire painting being used as an exclusive subject. Landseer was a consummate technician and, at his best, a master of brushwork: the original is beautifully painted. The interest in Blake's version lies in his affectionate tribute to an outstanding Victorian artist, and in the pervasive banality of the image itself.

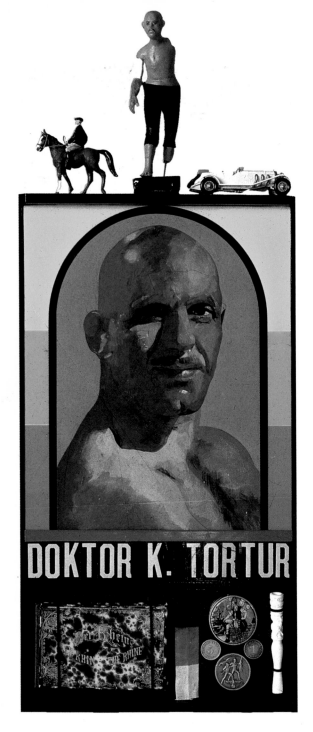

33 *Doktor K. Tortur* (1965)
Cryla, collage on hardboard
24 x 10in (61 x 25.4cm)
Erich Sommer

Doktor Tortur is a bald and bulky German wrestler, a figure of somewhat sinister implacability whom Blake conjured up from his imagination. He has added a number of real attributes to the painting: at the top a maimed figurine, a toy horse and rider of a rather aristocratic kind, and a model of a Mercedes car; below, we find a cigarette holder, a ribbon in the colours of the German flag, a charmingly vulgar powder compact bought in Dublin, a German sports medal and German coins. Once again we are invited to imagine a whole character, a person with strong preferences and tastes, about whom Blake has provided substantial clues.

Indeed, one of his most satisfactory transfers from one medium to another was *Babe Rainbow* (**34**) – an image which must be familiar to millions now as an archetype of student bed-sitting room decoration. For example, in the spring of 1985 *Babe Rainbow* could be spotted setting the tone in the living quarters of a semi-Bohemian London research student, estranged from his conventional professorial father, in the BBC television series 'Late Starter'.

36 *Mark, Henrietta and Charlie Boxer* (1965)
Cryla on hardboard
14 x 12in (35.6 x 30.5cm)
Mark Boxer

One of Blake's few commissioned portraits portrays
Mark Boxer and two of his children – to note his
departure as editor of *The Sunday Times Magazine*, the
first of the newspaper colour magazines and the one
which provided the term 'colour supp' to indicate the
kind of 'Habitat' life-style that was rapidly becoming a
part of social culture in the 60s. Blake was among a
number of artists involved in extremely imaginative
projects for the magazine, whose role in bringing to the
attention of a wide public the work of young
contemporary artists should not be underestimated.
Mark Boxer is a cartoonist of considerable satiric power
whose 'Life and Times of NW1', among other sustained
comic inventions, both questioned and portrayed the
life and style of which he was part. Both Boxer and
Blake, in their different ways, report, analyse and
influence.

war and the austere 50s, travel became
possible and attractive to many, but es-
pecially to the young. As we have seen,
Blake went trawling for appearances of
popular and folk culture in northern Europe
just after he finished studying at the Royal
College and he visited Los Angeles in 1963
for *The Sunday Times Magazine*.

The atmosphere in the 60s was trans-
atlantic. Blake painted America before he
visited the country, and Americans were
coming to England in ever greater numbers.
Blake's wife, the sculptor Jann Haworth,
whom he married in 1963, was an American
from California who, after studying art in
the USA, came to study at the Slade School
of Art in London. R. B. Kitaj, an expatriate
American who has been one of the most
influential painters of his generation,
studied at the Ruskin School of Art in
Oxford and at the Royal College. Hockney
was to make seminal, influential visits to
California and bring back genial, sophisti-
cated paintings. In the aftermath of the
Second World War and during the iciest
patches of the Cold War, brilliantly colourful
abstract expressionism, supported by the
active cultural diplomacy of the United

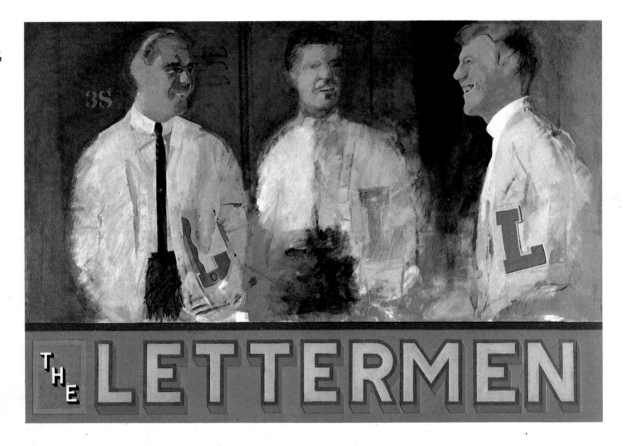

37 *The Lettermen* (1963)
Oil on hardboard
49 x 73in (124.5 x 185.4cm)
City of Kingston upon Hull Museums and Art Galleries

The Lettermen were an American rock group whose name refers to the letters given to American college sportsmen in recognition of their sporting achievements and worn on the team sweaters. The look would have been considered quite classy, the equivalent of 'preppy'. Blake liked the music of the group and based his painting on one of their record covers.

38 *The Beatles* (1963–8)
Cryla on hardboard
48 x 36in (121.9 x 91.4cm)
Private collection

Typically Blake based his images on magazine photographs, in this case taken on the Beatles' return from Germany shortly before they became overwhelmingly and globally famous. The four musicians are portrayed as they appeared in the months of their first fame: solemn, poignant and boyish, with a wistful air of old-fashioned formality. Something of Blake's warm appreciative enthusiasm – even affection – comes across in what is a relatively simple portrait group, but one that carries a subtle emotional charge.

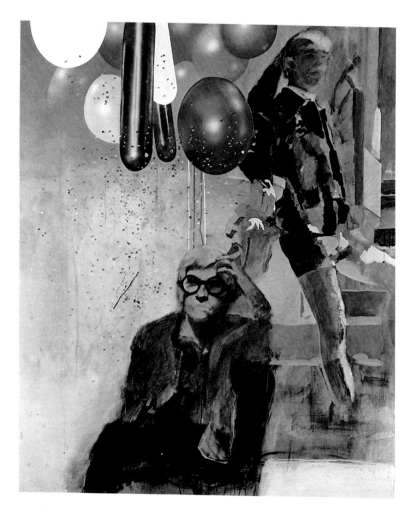

Blake as a fan, as a member of the audience, was drawn towards legendary personalities as often as to the quality of performance. In the 50s and 60s he was attracted, he has said, to the idea of Elvis as legend rather than performer and to Marilyn Monroe as performer in her early cheese-cake films, whom he admired unreservedly and without any of the over-intellectualizing which was to become so endemic – although Monroe was not to become a theme for Blake, other stars did. Indeed, one of the absorbing aspects of his art is the multi-faceted nature of his response to the many sources of his imagery: unaffected wonder, delight and enjoyment mingle with an

41 *Portrait of Sammy Davis Jr* (1960)
Oil on hardboard
14½ x 12½in (36.8 x 31.7cm)
Private collection

omnivorous enthusiasm and a very wide knowledge. His responses are direct: he is never slumming. Words like 'homage' have been used in the titles that Blake gives his paintings and he unashamedly calls himself a fan. A portrait of Sammy Davis Jr, of which one version still exists (**41**), was actually left by the artist as an offering for the entertainer at the hotel where Sammy Davis was staying on a visit to London at the end of the 50s. In Blake's painting of the Beatles he left space for their autographs (**38**). There is in his paintings that sense of anticipation, of escapism and of admiration that embraces the child in the cinema. Perhaps this can be

seen as stemming from that early painting of 1955, *ABC Minors*, which shows two schoolboys with wide eyes set in very big heads and with small bodies – early fans, members of a children's cinema club as Blake himself was during the war.

A striking number of Blake's early paintings refer to childhood: from the early to mid-1950s there were several versions of such images as *Children reading Comics* (**43**). His response to topics set by the Royal College – *On the Balcony* (**18**) was one, as we have seen, and *The Entry into Jerusalem* (**44**) another – was to place them firmly in a world where the idea of a show mingled firmly

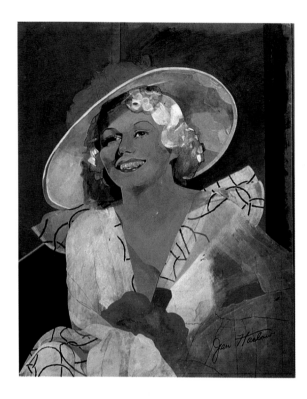

42 *Jean Harlow* (1964)
Cryla on hardboard
17½ x 14½ (44.5 x 36.8cm)
Mr and Mrs Terry Blake

Commissioned for the cover of *The Sunday Times Magazine*, 22 November 1964.

with the idea of childhood. Yet Blake's children invariably have large and very strongly featured faces which, if detached from their square-set and often sexually ambiguous bodies, could be any age from eight to twenty-eight. This is equally true of his entertainers, whether imaginary or real: although the content is firmly that of the adult world, the faces can often, but not invariably, be read as doll- or child-like.

Blake, an inveterate collector, has rifled the shelves of his own past and present. He has used that which he has known about from only second, third or fourth hand. Rather than, say, going to North Africa as

Matisse did – making a pilgrimage to that continent of strange light and experiencing an exotic mélange of cultures, types and religions – Blake has preferred at times to mediate and meditate on media. For example, there was the series, already mentioned, based on postcards of the people of Constantinople, executed by Blake in the mid-60s (**45–6**). Then in the 70s he did some drawings based on photographs that had been published in 'Nature and Culture', a 1928 survey which examined a wide variety of female types through the medium of photographs of the female nude (**48**).

But Blake has always worked directly

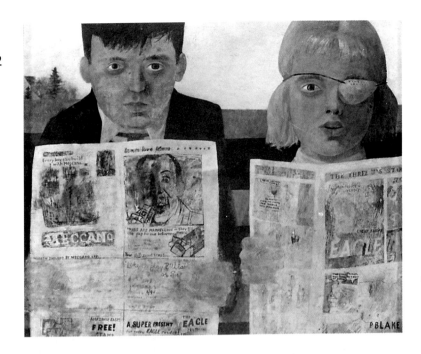

43 *Children reading Comics*
(1954)
Oil on hardboard
14½ x 18½ in (36.9 x 47cm)
Carlisle Museum and Art Gallery

from life too. Often his paintings combine a feeling of immediacy and direct observation with the sense of transmutation through layers of already existent interpretation – imagery wrought by others. This sense of direct response and received imagery, of traditions both high and popular, are inextricably entwined in his work. Unlike many artists who are associated with the use of popular imagery, Blake uses imagery which is always richly associative, often blurring fact with fiction: he as often creates from his imagination convincing popular icons which have no existent text except his own narrative as he takes from other sources. And, as we have seen, his interest in costuming and packaging is not like that of

Andy Warhol and his Campbell soup tin, or Jasper Johns and his beer cans. Blake does not isolate objects from the supermarket shelves. He has taken as his subjects the rare as well as the ubiquitous, resorting simultaneously to high art and the high street.

By the end of the 1960s Blake and his wife Jann Haworth had decided, as many artists before and since have done, to leave London for the country. In the process they became, by definition, 'ruralists', forsaking the cityscape for country life. The bucolic dream is very English – even stockbroker Tudor is a version. As one American commentator rather acidly put it, when an English artist gets on, he gets to Wiltshire. Certainly a number of Blake's close artist friends –

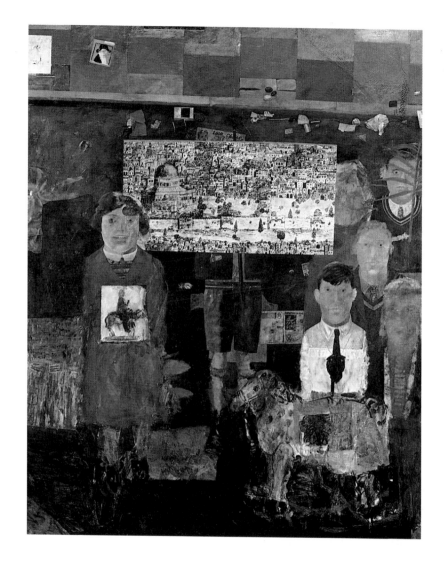

44 *The Entry into Jerusalem*
(1955–6)
Oil on hardboard
50 x 40in (127 x 101.6cm)
Royal College of Art

This major painting, like *On the Balcony* (**18**), was a set subject at the Royal College of Art, in this case for the 1955 Rome Scholarship. Blake has used the apparently opposed sensations of distance and intimacy in his version, which he has transmuted not into a treatment of the subject directly but into the idea of preparations for a Sunday School play. This allows all sorts of devices – the picture within a picture, the sense of childhood yet also of sophistication, the idea of entertainment and dressing up, and the image as mask – the boy holding a vast engraving of the city of Jerusalem – to enter the painting in an unforced manner. The children have smooth wide-eyed faces which could be of any age, and their bodies and stance recall early religious portraits.

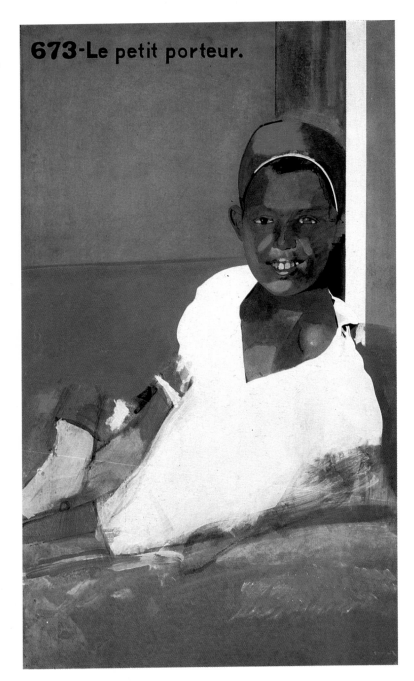

45 *Le Petit Porteur* (1964–5)
Cryla on hardboard
30 x 18 in (76.2 x 45.7 cm)
Private collection

Both paintings are derived from a
series of picture postcards, 'Salut de
Constantinople', whose subject
matter derived from the Middle East
and especially from Constantinople,
which were printed in Italy and
published in France around 1900.
Blake has intensified the impact of
the originals by heightening the
colour considerably, and has played
with different levels of definition and
focus to suggest a certain mystery
and a surprising emotional ambiguity
and richness. The paintings may be
seen as yet another variant in the
fascination with Oriental themes
expressed in the salon paintings of
British, French, German and Italian
artists during much of the nineteenth
century.

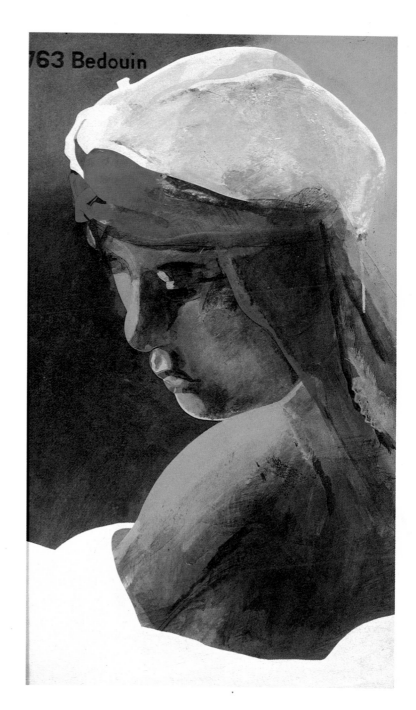

46 *Bedouin* (1964–5)
Cryla on hardboard
30½ x 18¾in (77.4 x 47.7cm)
Thyssen-Bornemisza Collection,
Lugano, Switzerland

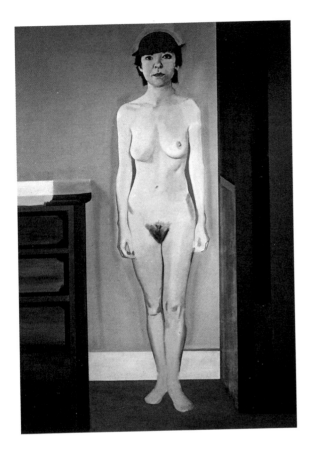

LEFT **47** *The Wedding Hat* (1981–3)
Oil on canvas
68½ x 48½in (174 x 121.9cm)
Peter Blake

The members of the Brotherhood of Ruralists agreed to paint what was for each of them 'The Definitive Nude' and the resulting paintings were shown together at Blake's Tate retrospective. *The Wedding Hat* was his image in the series.

RIGHT **48** *Czech Woman* (1973–7)
Pencil drawing
23 x 18in (58.4 x 45.7cm)
Private collection

This drawing was based on a photograph in 'Nature and Culture', a volume of photographs published in 1928.

Richard Smith, Joe Tilson, Howard Hodgkin among them – were living in the country.

The atmosphere in Blake's work was to change for much of the 1970s. Fairies and Alice entered in, somehow and understandably concomitant with ruralist life and parenthood. Attachments to real life also continued. *Liberty Blake in a Kimono* (**10**) shows Blake's elder daughter aged about three, and was drawn for a Habitat reproduction in 1971. Right from his own beginning as an artist Blake was interested in the 'nostalgia of folk-pop' as he put it; but, unusually for an artist, not only was he not above the idea of being popular, he was also willing to admit his satisfaction at being so.

While Blake's wife Jann was to start the Looking Glass School for young children in Somerset, they both founded with a group of like-minded artists, some of whom were emergent and regarded Blake with delight for his faith in their work, the Brotherhood of Ruralists in 1975. The Ruralists have been commemorated in one major exhibition.

They shared not style, but sympathy, and attracted an unusual amount of both praise and adverse criticism. They took their annual holiday together. They were in a sense omnivorous, and in that sense Victorian; they saw visual imagery almost as a seamless whole, able to connect disparate images. They were not retrograde but reactionary in a non-pejorative sense. An intense attention to detail, and to the reconciliation of disparate worlds, was often a feature: dream-like paintings (by David Inshaw), compilations and collages (by Graham Arnold) and a remarkably empathetic understanding of the countryside (by Ann Arnold), were among the characteristics of the Ruralists. Some turned their attention to objects, Jann Haworth in particular becoming interested in masks and costumes. All were involved in the imaginative world of the Victorians.

The idea of collaboration and co-operation seems as natural to Blake, for all his own high individualism and idiosyncracy, as the

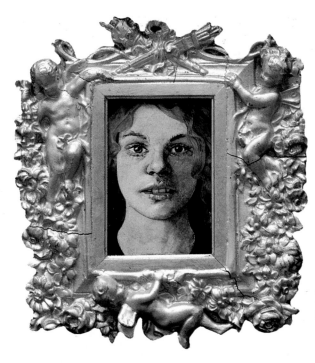

49 *Eglentyne* (1981–2)
Oil on hardboard
3½ x 3½in (8.9 x 8.9cm)
Private collection

idea of collage, assemblage, mixed media and mixed references in his art. It was his influence which helped to ensure that the seven artists who made up the Brotherhood of Ruralists (Ann and Graham Arnold, David Inshaw, Annie and Graham Ovenden, Jann Haworth and Blake himself) had something of a public presence as a group. In 1976, a year after their foundation, there was a group showing in the Royal Academy Summer Exhibition, the hanging devised by Blake. (In 1974 Blake had been elected as Associate Member of the Royal Academy, and in 1981 he was elected a full Royal Academician.) In 1977 there was a BBC TV film about the Ruralists, 'Summer with the Brotherhood', by John Read. In

1983 he invited the other artists of the Brotherhood (by then the group had been slowly dissolving for a few years) to contribute to his Tate Gallery retrospective a wall of paintings on 'The Definitive Nude' (**47**): in the event a series of charming full-length naked ladies depicted with varying degrees of skill.

Blake, a gentle and mild mannered man, is wholly unafraid of dispute, unlike most British artists. In 1977 he mounted in effect a one-man statement of intent within the Hayward Annual in which paintings labelled 'work in progress' and costumes were included, as well as an open letter by Blake to writers on art whom he discerned as creating a climate inimical to the art in which

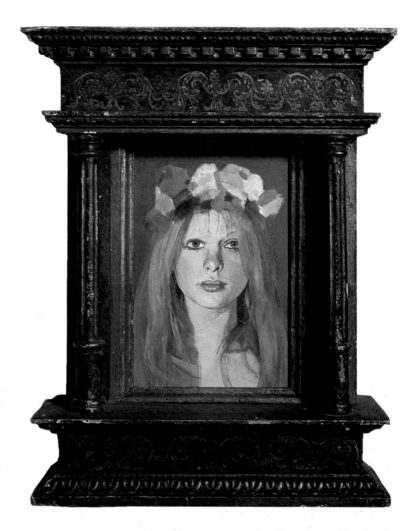

50 *Flora – Fairy Child* (1977)
Oil on hardboard
6¼ x 4½in (15.9 x 11.4cm)
Private collection

Blake has said that he sees fairies as fringe entertainers, grouping them in a loose connection with pin-ups, wrestlers, strippers, circus folk and others who are not fully accepted on to the centre of the stage. Fairies are elusive, and Blake grew interested in them when, as a father reading stories to his daughters, he became involved in children's literature. His early years of parenthood were combined with West Country living, and he made this crown of flowers himself, working from photographs of it for the portrait. The fairy creature is not in the least ethereal. The robust vitality she exudes is as much a feature of his portraits of imaginary entertainers as of real people: in fact, it often seems that the more imaginary the subject, the more robust the portrayal. As in many of his child and fairy paintings, the girl appears curiously grown up. His females of whatever character usually have the same wide-eyed look and full generous mouth. The frame is integral to the painting, recalling the elaborate frames of early Renaissance pictures.

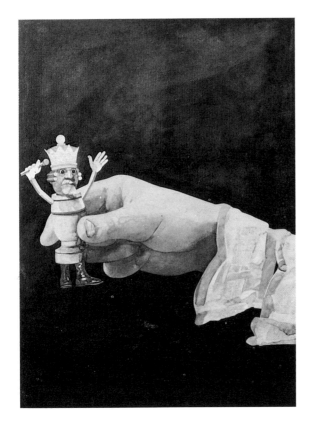

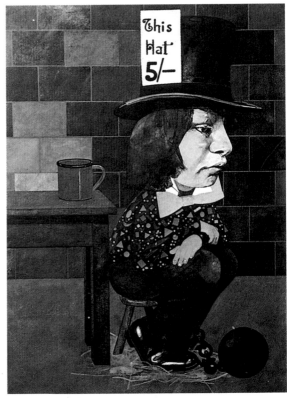

51–6 Illustrations to *Through the Looking Glass* (1970–1)
Watercolours
image size 10 x 8 in (25.4 x 20.3 cm)
paper size 26 x 21 in (66 x 53.3 cm)

Blake took a series of photographs as tableaux to work from for these illustrations, made first as watercolours and then as prints. The landscape backgrounds were derived from Holland and Somerset.

LEFT **51** '*So Alice picked him up very gently*'
Deweer Art Gallery, Zwevegem-Otegem, Belgium

RIGHT **52** '*For instance, now there's the King's messenger*'
Private collection

he believed. The correspondence and criticism that ensued frothed most in *The Guardian*, provoking a debate unusually full of feeling for the normally insipid English art world. In his 1983 Tate exhibition he set out the debate again, but more obliquely, by including 'Good Reviews' and 'Bad Reviews' in a pamphlet which accompanied the catalogue. The good review section included praise from the *Elvis Monthly* for a portrait of Elvis.

In 1979 Blake and his wife Jann Haworth separated, and he also gave up permanent

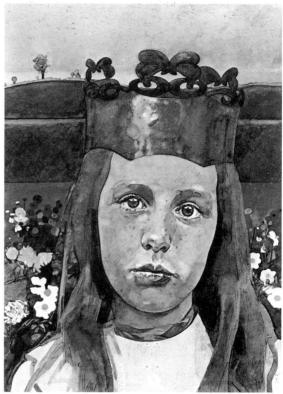

life in the country, returning to West London. There he lives and on occasion works with Chrissy Wilson, an exceptionally gifted artist, miniaturist in scale, and model maker. The *Sculpture Park* (**57**) at the Tate retrospective was almost entirely made by her. She shares with Blake a gift for the exquisite nicety, a pleasure in both draughtsmanship and craftsmanship, and a feeling for the necessary rightness of context. This has often been expressed in Blake's work in the meticulous attention he pays to frames for his images, to ornament and even to

LEFT **53** '*and the two Knights sat, and looked at each other without speaking*'
Deweer Art Gallery, Zwevegem-Otegem, Belgium

RIGHT **54** ' *''Well this is grand!'' said Alice*'
Private collection

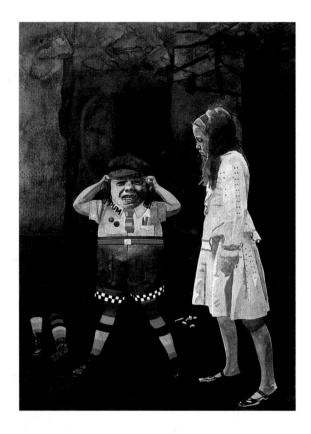

Illustrations to *Through the Looking Glass* (1970–1) cont.

LEFT **55** ' *"But it isn't old!" Tweedledum cried'*
Private collection

RIGHT **56** *'and to show you I'm not proud, you may shake hands with me!'*
Private collection

dressing up in terms of collages, assemblages and the like.

In the mid-1960s he began his *Portrait of David Hockney in a Hollywood-Spanish Interior* (**40**) – a curiously melancholy celebration with confetti and balloons. At the 1983 Tate retrospective this painting, owned by David Hockney, was exhibited as a 'work in progress'. Blake is often an obsessively slow worker, repainting and altering, and he has frequently exhibited work in progress. This has sometimes provoked a reaction replete with irony: those very same avant-garde critics, wedded to the idea of 'process' and 'concept', devoted to the charting of the stages of a work, have thought that to exhibit a work, which might have been changed by the time it was shown in another exhibition, smacked of pretension. Blake however is painfully honest – never disguising sources, exhibiting the unfinished, admitting to problems with work; although, again paradoxically, the silken smooth paintings of which he is more than capable, the marvellous ease of much of his work in final effect, makes the painfully hard labour

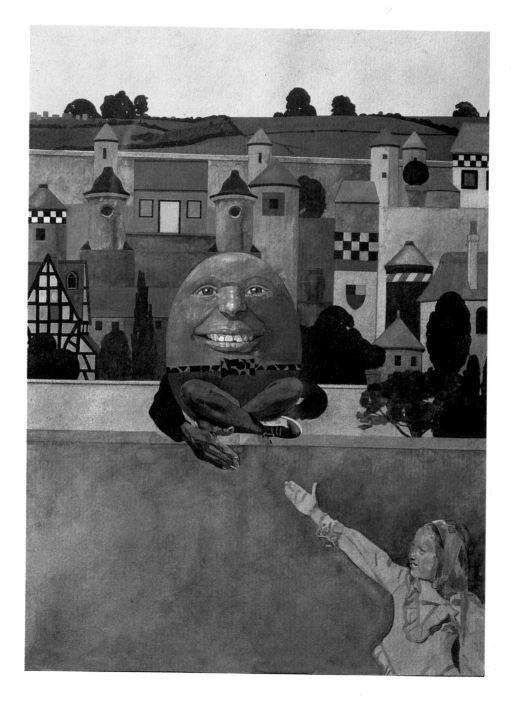

57 Peter Blake with *Sculpture Park* (1981–3)
Photograph by David Clarke
Mixed media
96 x 144in (244 x 365.5cm)
Peter Blake

that goes into them look easy. He is currently working towards an exhibition called 'work in progress finished' which will bring about a dozen of such paintings to a conclusion.

For all his deliberation Blake has been able to exploit chance too. One fine example is the watercolour of 1968–9, *Girl in a Poppy Field* (**58**). Blake, incidentally, is traditionally English in his ability to use watercolour, that most English of mediums, with the same skill that he uses paint – whether acrylic or oil. In this image he made a pattern of colours, experimenting with a variety of shades, hues and tones from a new watercolour box, then incorporated the resultant pattern as the garment of the young girl.

Any discussion about Blake will unavoidably linger on the work of the 1950s and 60s, for all the concerns that have since flowered so abundantly were present then. These include pop music – pop musicians are amongst Blake's good friends, and they are mutual fans; popular culture – the literature of fantasy; an absorbed interest in minutiae; a mingling of observation and imagination; and above all a continued interest – *the* central interest – in human kind. It is this concern that makes his work so attractive.

He is among the very few artists who have achieved both genuine popularity and critical appreciation.

Blake's popularity arises, it seems to me, from the fact that he touches on the popular imagination. He does this through his fascination with an enormous breadth of visual culture, which he responds to without ordering the images he uses into any heirarchical pattern.

Unlike other artists who have quarried popular culture, Blake does not put quotation marks around his material. It is this direct response, without any form of condescension, and the creative intermingling of the tradition of the fine arts and the popular arts – the lack of distinction as to worth between the found object and the painstakingly painted – that makes his work simultaneously complex, richly referential and readily accessible.

He is also a craftsman: the long process of creation for many of his paintings, his changes of mind, often carried out under the public gaze as 'work in progress' is exhibited over several years, is an aspect of his craftsmanship. He is never slick; he experiments with materials, scale, texture; he is unafraid of change, however consistent his

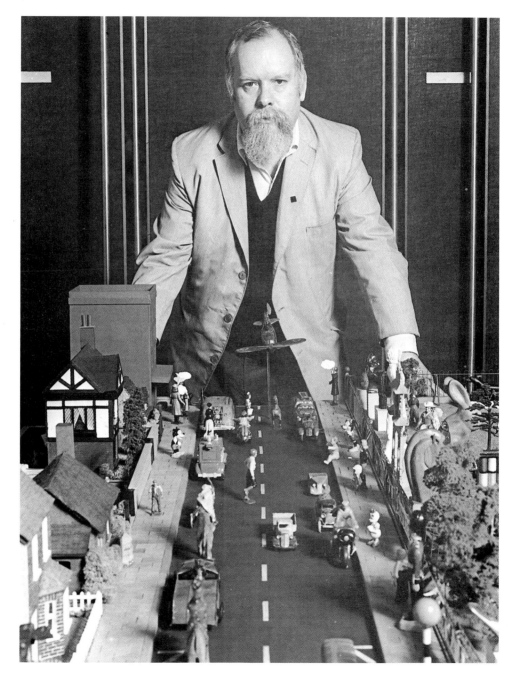

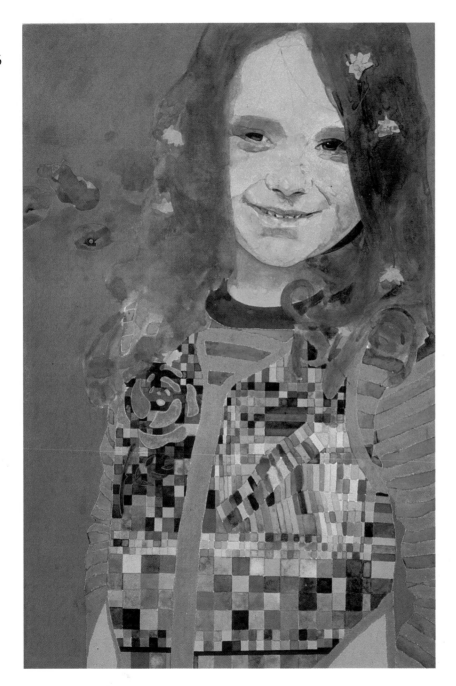

LEFT **58** *Girl in a Poppy Field* (1968–9)
Watercolour
16 x 11in (40.6 x 29.2cm)
Private collection

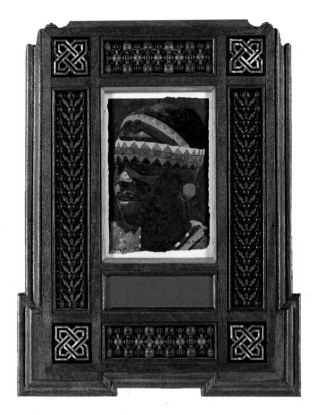

RIGHT **59** *Study for Tarzan meets Jungle Goddess II*
(1969)
Watercolour
5½ x 3¾in (14 x 9.5cm)
Private collection

themes and motifs. He is deeply generous to other artists and there is a steady interchange of work with his friends. This generosity, extending also towards the visual multi-culture with which we are surrounded, and the unsparing effort he makes in his work, are some of the reasons why his art has evoked such a strong and affectionate response.

Yet the English are ever suspicious of popularity. Blake's popularity itself has provoked hostility, as has his fascination with what at times might appear to be mere flights of whimsy. No matter: in the idiosyncratic mixing of fact and fantasy, reality and imagination, Blake is one of those rare artists who have invented a world recognizably their own. His world is an imaginative one parallel to the world around us, one that reinforces our perception both of the tangible world of observable reality and the inner world of the emotions.

Selected Bibliography

Books and articles about, by, or including references to, the artist.

Alley, Ronald. *British Painting since 1945*. London: 1966, pp. 12 and 42

Alloway, Lawrence. 'The Development of British Pop' in Lucy Lippard (ed.), *Pop Art*. London: 1966, pp. 28, 50 and 52

Amaya, Mario. 'Peter Blake: the ultimate fan male', *Studio International* (vol. 196, no. 847), 1983, pp. 31–3

Amaya, Mario. *Pop as Art: A Survey of the New Superrealism*. London: 1965, pp. 108–10

Bailey, David, & Peter Evans. *Goodbye baby and amen; a saraband for the Sixties*. London: 1969, pp. 42–4

Blake, Peter. 'Contrariwise'. *Aspects* (no. 3). 1978, pp. 1–2

City Art Gallery, Bristol. *Peter Blake*. Exhibition catalogue introd. by Roger Coleman. Bristol: 1969

Compton, Michael. *Art since 1945*. Milton Keynes: Open University, 1976, p. 49

Compton, Michael. *Pop Art*. London: 1970, p. 61

Dienst, Rolf-Gunter. *Pop Art*. Wiesbaden: 1965, pp. 55–6

Finch, Christopher. *Image as Language: Aspects of British Art 1950–1968*. Harmondsworth: 1969, pp. 69–72

Hackney, Stephen. 'Peter Blake: The Masked Zebra Kid', in Stephen Hackney (ed.), *Completing the picture: materials and techniques of twenty-six paintings in the Tate Gallery*. London: 1982, pp. 104–7

Kultermann, Udo. *The New Painting*. London: 1969, p. 173

Levy, Mervyn. 'Peter Blake: Pop art for admass' (mostly interview), *Studio International*, (vol. 166, no. 847), Nov. 1963, pp. 184–9

Lucie-Smith, Edward. *Art Today: From Abstract Expressionism to Superrealism*. Oxford: 1977, pp. 250–1, 485

Lucie-Smith, Edward. *Movements in Art since 1945*. Rev. ed. London: 1975

Melville, Robert. *Figurative Art since 1945*. London: 1971, pp. 199–200

Peter Stuyvesant Foundation. *Peter Stuyvesant Foundation: A Collection in the Making – 1965 Purchases*, introd. by Michael Kaye and Alan Bowness. London: 1965

Pierre, José. *Pop Art: an illustrated dictionary*. London: 1977, pp. 30–1

Robertson, Bryan, John Russell and Lord Snowdon. *Private View*. London: 1965, pp. 224–7

Russell, John, and Suzi Gablik. *Pop Art Redefined*. London: 1969, p. 40

Sammlung Ludwig im Wallraf-Richarz Museum. *Kunst der sechziger Jahre: Sammlung Ludwig im Wallraf-Richartz Museum, Köln*, introd. by Gert von der Osten, Peter Ludwig, *et al*. 4. verbesserte Auflage. Cologne: 1970

Shone, Richard. *The Century of Change: British Painting since 1900*. Oxford: 1977, pp. 40, 210–11

Tate Gallery. *Peter Blake*. Exhibition catalogue introd. by Michael Compton, Nicholas Usherwood, Robert Melville. London: 1983

Tono, Yoshiaki (ed.) *The Pop Image of Man*. Tokyo: 1971 (*Art Now*, 4), p. 82. Japanese text

Usherwood, Nicholas. *The Brotherhood of Ruralists*. London: 1981

Waddington and Tooth Galleries. *Peter Blake: Souvenirs and Samples*. Exhibition catalogue introd. by Peter Blake. London: 1977

Wilson, Simon. *Pop*. London: 1974, pp. 41–4

Acknowledgements

The author and publishers would like especially to
thank Peter Blake for his help during the preparation
of this book, and also the following who have kindly
either given permission for their pictures to be repro-
duced or supplied photographs:

Arts Council of Great Britain
Mark Boxer
City of Bristol Museum and Art Gallery
Carlisle Museum and Art Gallery
David Clarke/Tate Gallery Press Office
Fleur Cowles
Prudence Cuming Associates
Alex Dufort/*The Sunday Times*
Museum Boymans-van Beuningen, Rotterdam
Museen Ludwig, Cologne
Richard A. Rapaport
Royal Academy of Arts
Royal College of Art
Tate Gallery
Victoria and Albert Museum
Waddington Galleries Ltd
John Webb

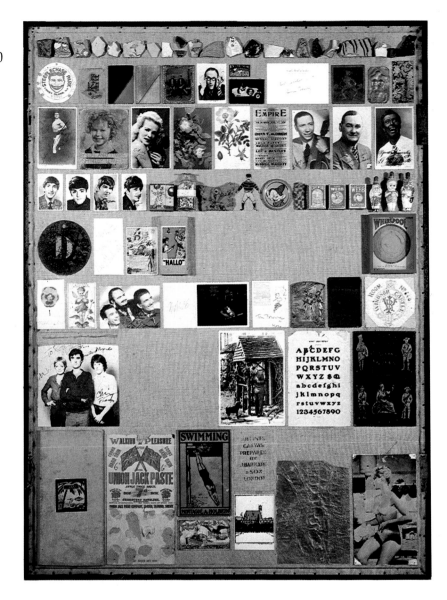

60 *A Museum for Myself* (1982)
Collage
45⅜ x 33⅞ in (115.3 x 86cm)
Peter Blake

Index

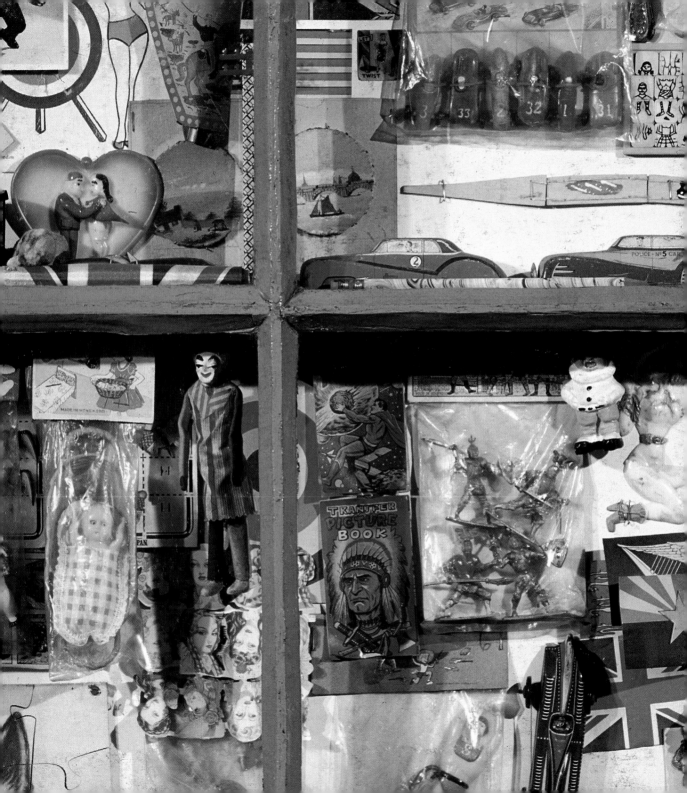